MARURU

Pot.

2/2

PAUL GAUGUIN

Also by David Sweetman

Van Gogh: His Life and His Art Mary Renault Looking into the Deep